Draw

Horses

DAVID BROWN

Series editors: David and Brenda Herbert

A & C Black • London

First published in 1981
New style of paperback binding 1997
By A&C Black Publishers Limited
38 Soho Square, London W1D 3HB
www.acblack.com

Reprinted 1999, 2004, 2007

ISBN-10: 0-7136-8306-6
ISBN-13: 978-0-7136-8306-6

Cover design by Emily Bornoff

Printed in China by WKT Company Limited

This book is produced using paper that is made from
wood grown in managed, sustainable forests. It is natural,
renewable and recyclable. The logging and manufacturing
processes conform to the environmental regulations
of the country of origin.

Contents

Making a start

Learning to draw is largely a matter of practice and observation—so draw as much and as often as you can, and use your eyes all the time. The less you think about *how* you are drawing and the more you think about *what* you are drawing, the better your drawing will be.

The best equipment will not itself make you a better artist—a masterpiece can be drawn with a stump of pencil on a scrap of paper. But good equipment is encouraging and pleasant to use, so buy the best you can afford and don't be afraid to use it freely.

Experiment with the biggest piece of paper and the boldest, softest piece of chalk or crayon you can find, filling the paper with lines to get a feeling of freedom. Even if you think you have a gift for tiny delicate line drawings with a fine pen or pencil, this is worth trying. It will act as a 'loosening up' exercise. The results may surprise you.

Be self-critical. If a drawing looks wrong, scrap it and start again. A second, third or even fourth attempt will often be better than the first, because you are learning more about the subject all the time. Use an eraser as little as possible—piecemeal correction won't help. Don't re-trace your lines. If a line is right the first time, leave it alone—heavier re-drawing leads to a dull, mechanical look.

HORSE

What to draw with

Pencils are graded according to hardness, from 6H (the hardest) through 5H, 4H, 3H, 2H, to H; then HB, through B, 2B, 3B, 4B, 5B, up to 6B (the softest). For most purposes, a soft pencil (HB or softer) is best. If you keep it sharp, it will draw as fine a line as a hard pencil but with less pressure, which makes it easier to control. Sometimes it is effective to smudge the line with your finger or an eraser, but if you do this too much the drawing will look woolly. A fine range of graphite drawing pencils is Royal Sovereign.

Charcoal (which is very soft) is excellent for large, bold sketches, but not for detail. If you use it, beware of accidental smudging. A drawing can even be dusted or rubbed off the paper altogether. To prevent this, spray with fixative. Charcoal pencils, such as the Royal Sovereign, are also very useful.

Pastels (available in a wide range of colours) are softer still. Since drawings in pastel are usually called 'paintings', they are really beyond the scope of this book.

Pens vary as much as pencils or crayons. The Gillott 659 is a very popular crowquill pen. Ink has a quality of its own, but of course it cannot be erased. Mapping pens are only suitable for delicate detail and minute cross-hatching.

Special artist's pens, such as the Gillott 303, or the Gillott 404, allow you a more varied line according to the angle at which you hold them and the pressure you use.

Reed, bamboo and quill pens are good for bold lines and you can make the nib end narrower or wider with the help of a sharp knife or razor blade. This kind of pen has to be dipped into the ink.

Inks also vary. Waterproof Indian ink quickly clogs the pen. Pelikan Fount India, which is nearly as black, flows more smoothly and does not leave a varnishy deposit on the pen. Ordinary fountain-pen or writing inks (black, blue, green or brown) are not so opaque and give a drawing more variety of tone. You can mix water with ink to make it thinner but for Indian ink use distilled or rain water because ordinary water will make it curdle.

Ball point pens make a drawing look a bit mechanical, but they are cheap and fool-proof and useful for quick notes and scribbles.

Fibre pens are only slightly better, and their points wear down quickly.

Felt pens are useful for quick notes and sketches, but are not good for more elaborate and finished drawings.

Brushes are most versatile drawing instruments. The biggest sable brush has a fine point, and the smallest brush laid on its side provides a line broader than the broadest nib. You can add depth and variety to a pen or crayon drawing by washing over it with a brush dipped in clean water.

6B CHISEL PENCIL

CHARCOAL

BRUSH HANDLE DIPPED IN INK

Mixed methods are often pleasing. Try making drawings with pen and pencil, pen and wax or wax crayon and wash. And try drawing with a pen on wet paper.

Experiment with various media. Discover their range and limitations. You will probably find that you prefer one to the others, so use it. If you don't enjoy your work, your enthusiasm will diminish. There's no point at this stage in struggling with a medium you don't like, but delay your decision until you have tried as many as possible. This does not mean that you should abandon all other media. When you have gained confidence with your chosen one, try the others again; you will be surprised what a little experience and confidence can do.

FIBER PEN/BROAD

FIBER PEN/FINE

FRENCH STICK

FELT MARKER

BRUSH & PAINT

INK & FINGER

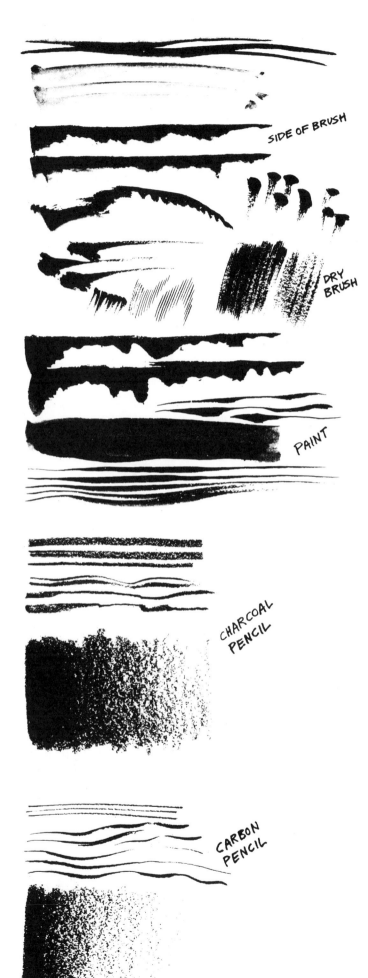

SIDE OF BRUSH

DRY
BRUSH

PEN & INK

PAINT

CHARCOAL
PENCIL

CARBON
PENCIL

Anatomy

To understand the shape of a horse, it is helpful to know something about its anatomy. Museums with natural history departments often have skeletons that you can study and sketch, and many books contain skeletal sketches. A drawing such as the one here shows which bones come near to the surface and therefore affect the horse's outline. It also shows the angles made as one bone joins another. This kind of information will help you to be accurate and realistic when you draw a living horse.

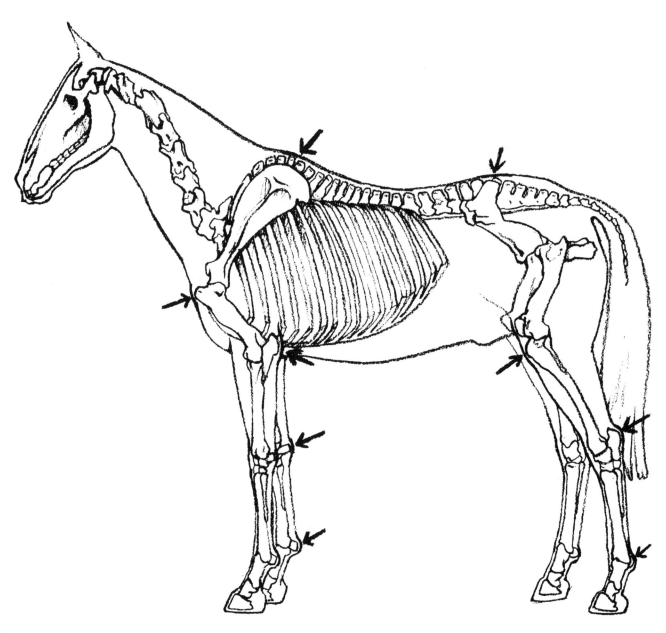

Shown here are the muscles which directly affect the surface area.

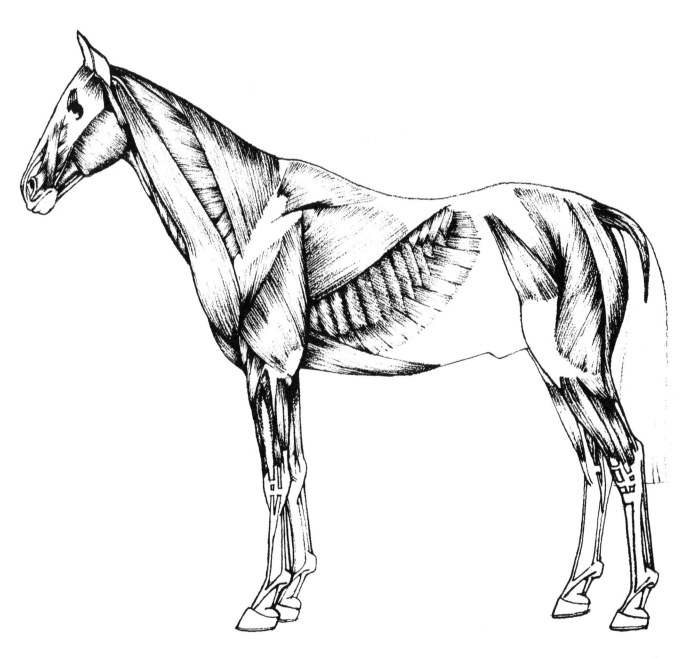

Proportion and structure

The commonest mistake in drawing is getting the proportion wrong. One way to avoid this is to use the head as a unit of measurement. Hold your pencil at arm's length, as shown here. Place the top of the pencil in line with the top of the animal's head. Then put your thumb on the pencil to line up with the chin.

You now have a unit of measurement which can be used to work out how many heads make up the animal's height. Draw in the head roughly and, with the help of your unit of measurement, mark out the number of heads you need to get the correct height and width. Be sure to keep your thumb on the same spot on the pencil, and the pencil at arm's length.

You also need to get the correct pose. To do this, hold your pencil vertically, making sure it is at a right angle to the floor. Line it up with the animal's nose. Run your eyes down the pencil, taking note of the position and angle of the various parts of the body in relation to the vertical line made by the pencil. Then move the pencil sideways to other areas of the subject as in the sketch below right.

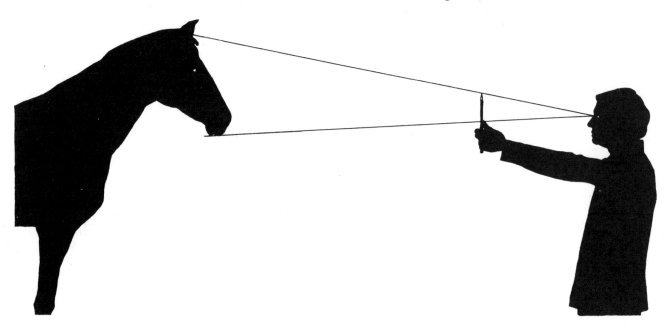

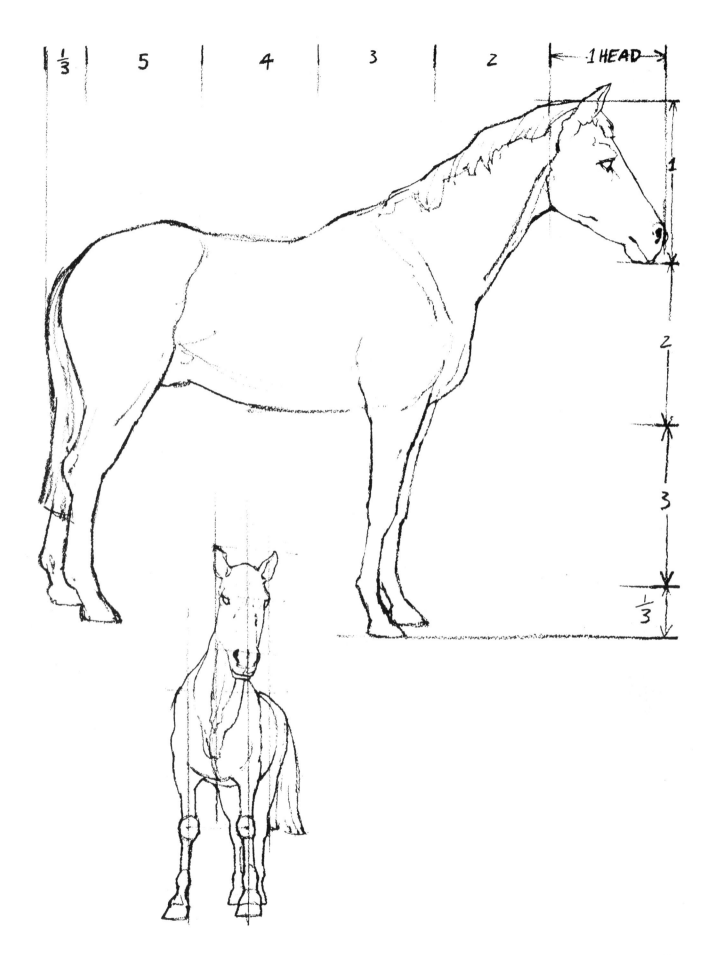

$\frac{1}{3}$ 5 4 3 2 1 HEAD

1

2

3

$\frac{1}{3}$

13

Drawing parts

Study the various parts of the horse's body separately and in detail. A body is symmetrical, which makes the job of analyzing its shape a lot easier. The drawings of heads below show how the structure can be broken down into patterns.

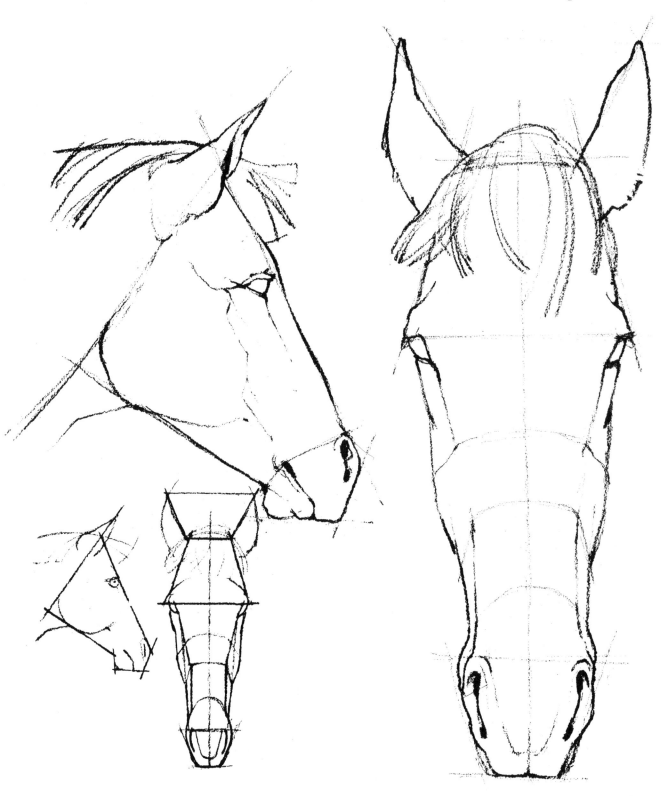

These drawings show the difference in shape between the heads of a workhorse (above) and a racehorse (below).

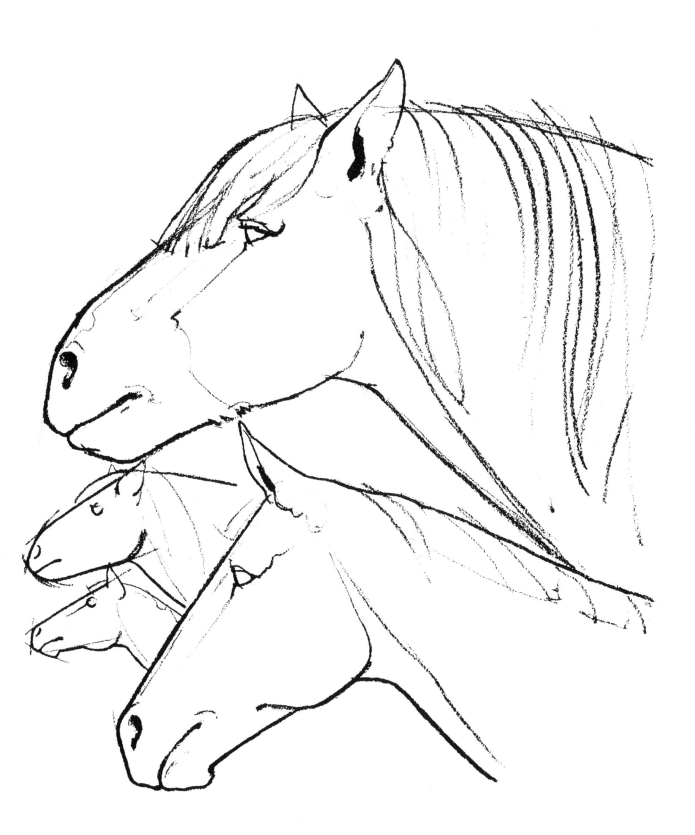

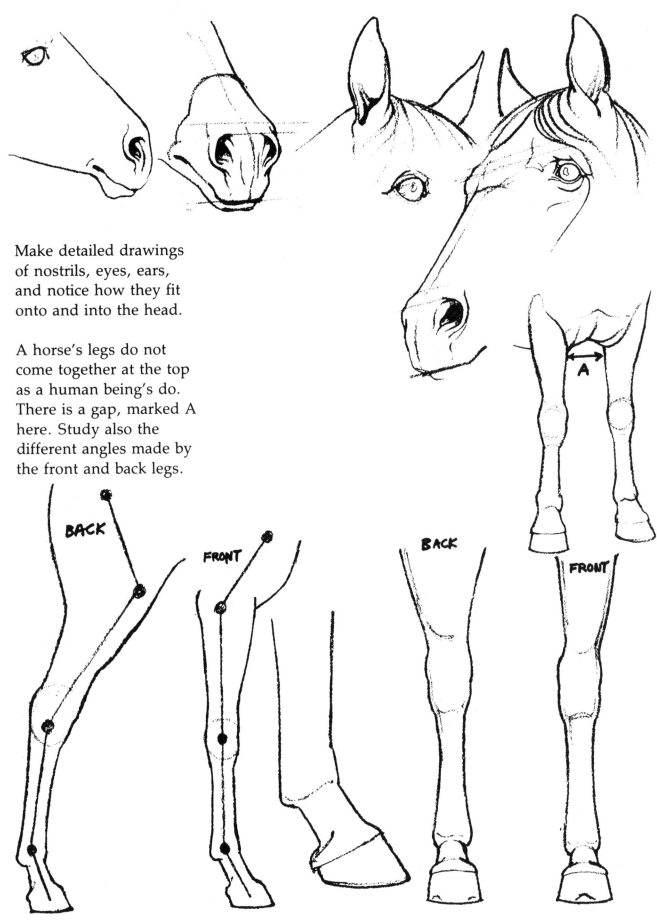

Make detailed drawings
of nostrils, eyes, ears,
and notice how they fit
onto and into the head.

A horse's legs do not
come together at the top
as a human being's do.
There is a gap, marked A
here. Study also the
different angles made by
the front and back legs.

BACK

FRONT

BACK

FRONT

A

Draw various features from different viewpoints to get an overall knowledge of their structure. This is a slightly unusual view of a horse's head. The sketches below show the difference between the legs of a powerful workhorse and a hunter.

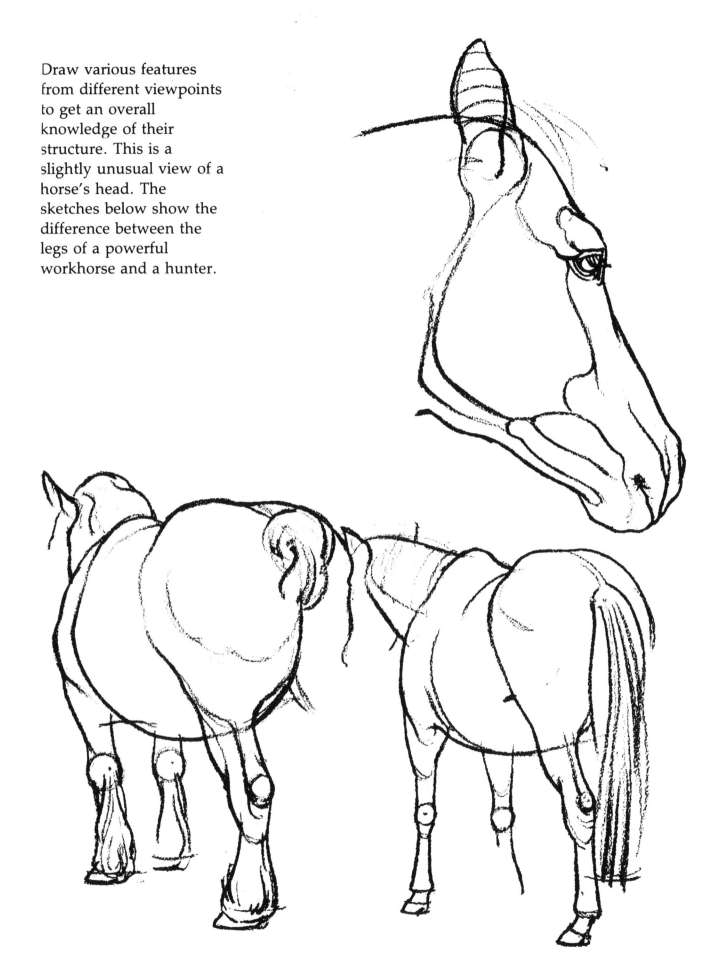

Body shapes

To understand the body shapes better, try breaking them down into a series of simplifed sections. (If you work from photographs, you will have plenty of time to make your own analysis—but make sure to use good quality photographs only.) Then try fuller drawings of different kinds of horse as in the following pages.

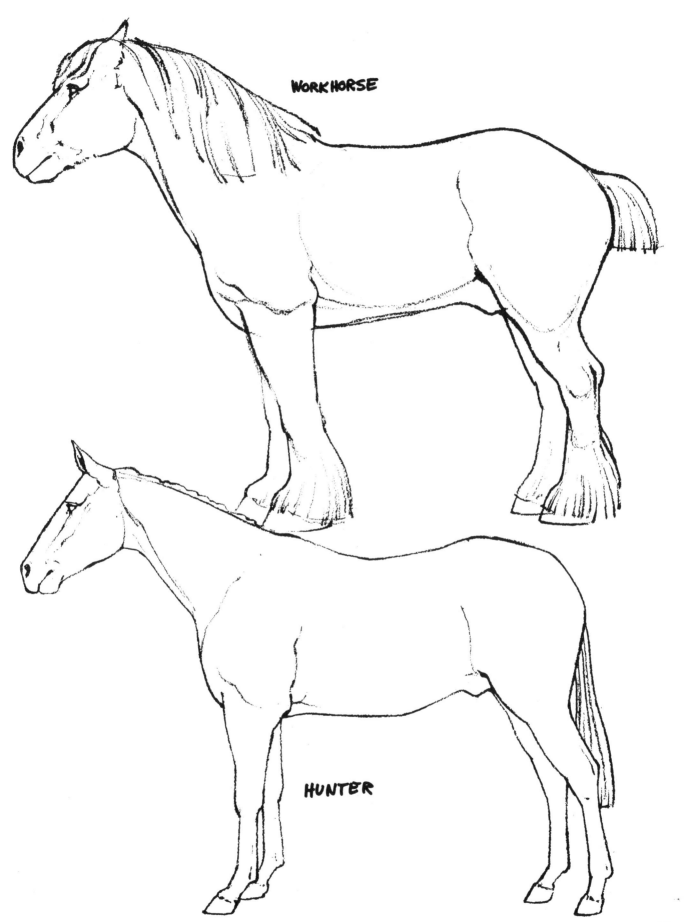

WORKHORSE

HUNTER

The bottom drawing is of a Welsh Mountain pony, the top one of a Shetland. Notice the difference in structure.

PONIES

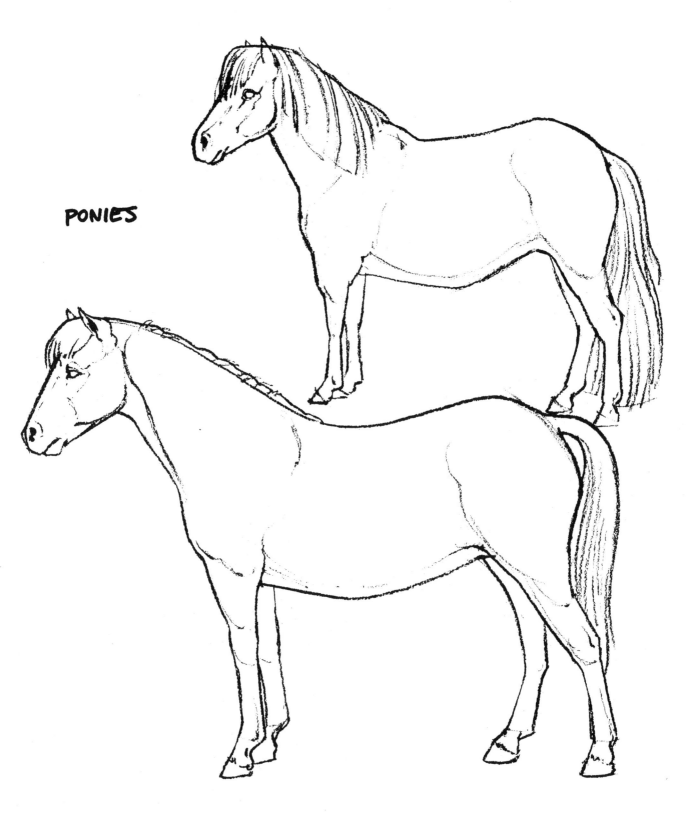

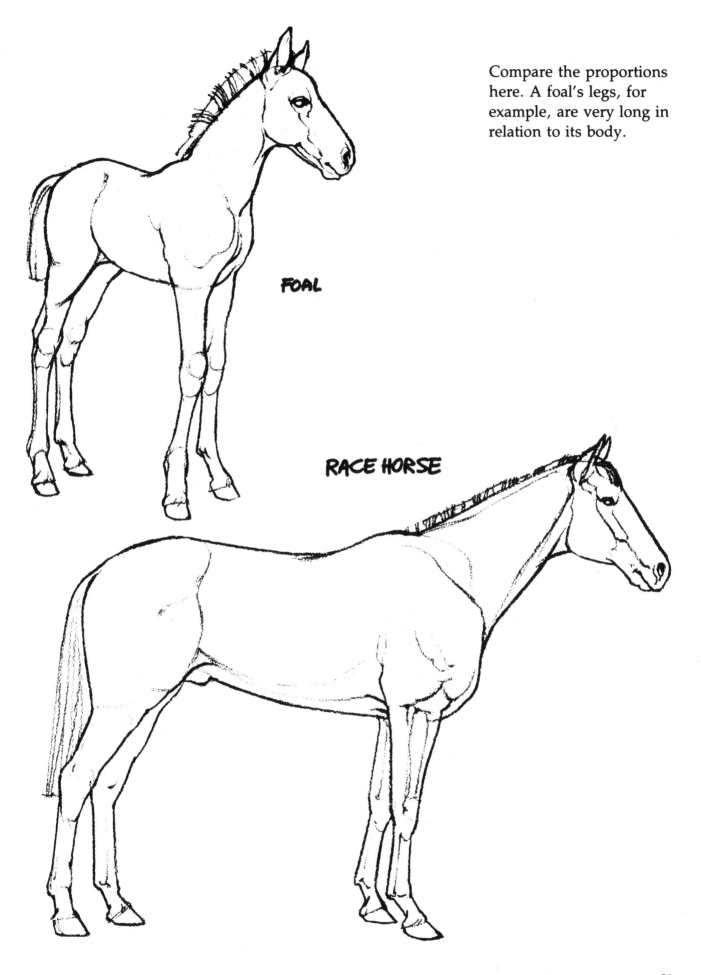

Compare the proportions here. A foal's legs, for example, are very long in relation to its body.

FOAL

RACE HORSE

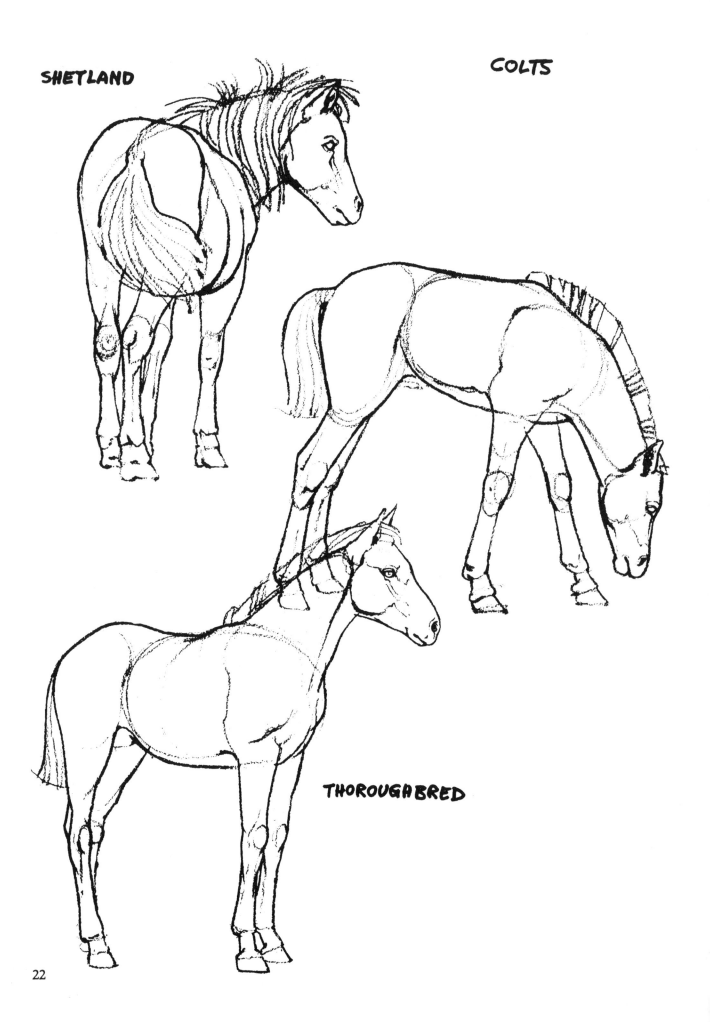

SHETLAND

COLTS

THOROUGHBRED

22

Composition

Cut out two pieces of card so that they form corners. Hold them up between you and your subject. Position them so that the inside edges of the card touch the outside edges of the subject (A). This will show you the proportion of the area taken up by the animal's body, and will help you to compose or position your drawing on the paper. In B the pieces of card are used as an adjustable picture frame, to help you decide how much of the subject you want to include.

Alternatively, draw in the middle of a large piece of paper, and cut the paper afterwards to make a composition that pleases you.

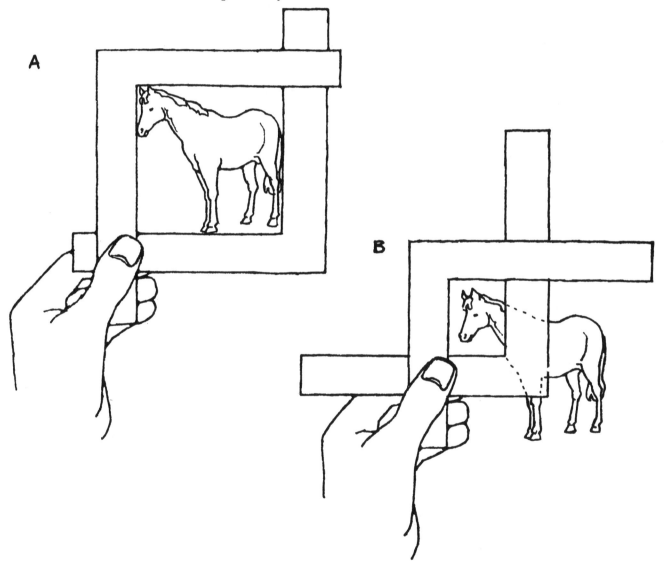

Step-by-step: the head

Here and on the following pages, drawings are developed from first basic lines to completion. In the first stage of any drawing, it helps enormously to add imaginary construction lines like those marked below. These are lines that you won't in fact put in once you become practised—but even then your pencil will go through the motions of adding them, while it only contacts the paper when drawing the actual features.

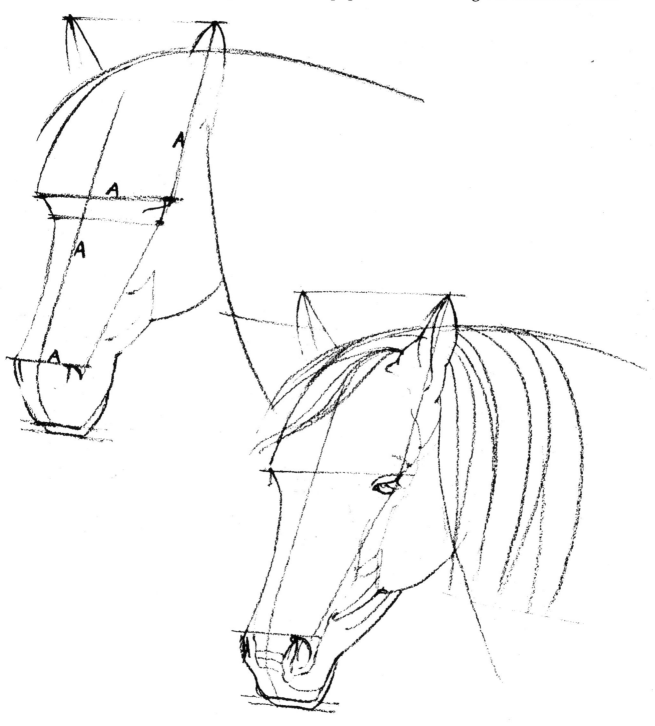

At every stage in a drawing, compare the length, width and shape of the various areas. Check, for example, whether the distance between the eyes is the same as the distance between eyes and nostrils. Don't put in the final shading without noting first where the light is coming from.

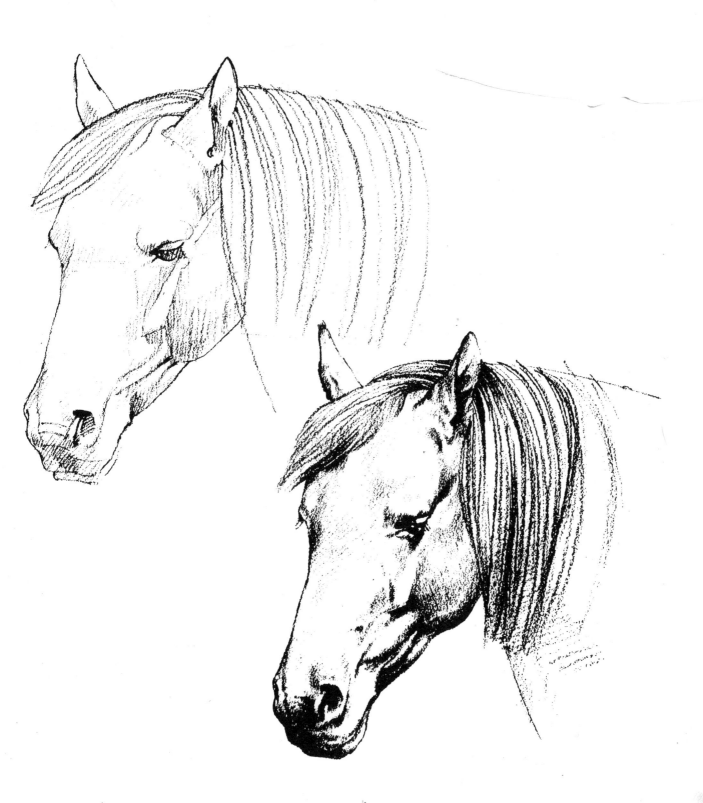

Step-by-step: the body

When starting a drawing, it sometimes helps you to see your subject in its simplest form if you half-close your eyes. By doing so, you shut out most of the detail, which makes it easier to concentrate on basic shapes. The drawing here was made with a B pencil on cartridge paper.

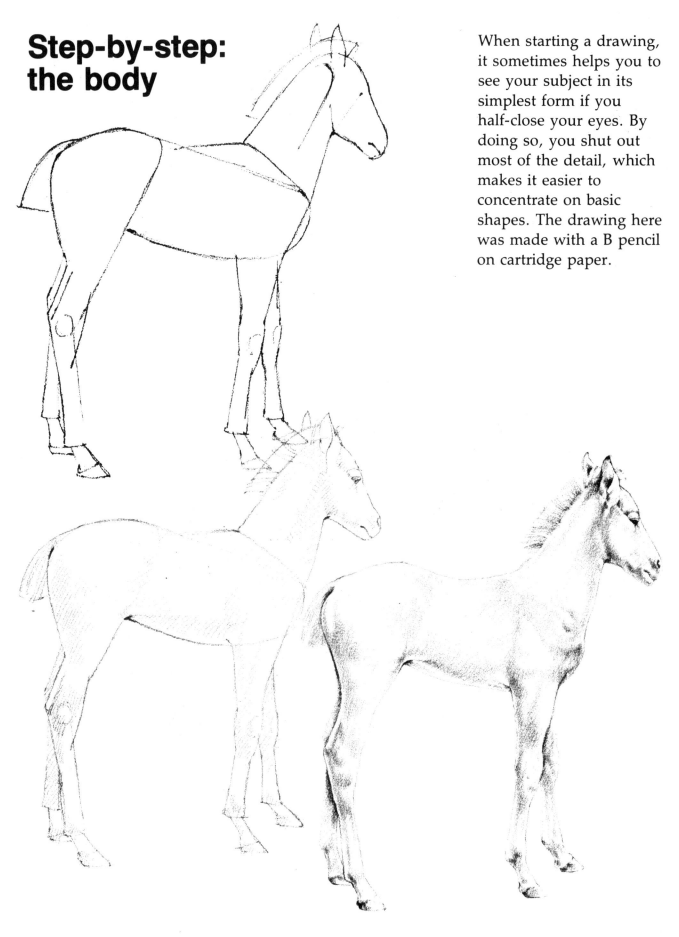

The basic shape of this Andalusian was sketched in with a carbon pencil; the drawing was finished with a stick of charcoal.

This drawing of a
Percheron is more
ambitious. The basic lines
were drawn with a 6B
pencil and then shaded.
The result was rubbed
with a French Stick
(tightly-rolled card) and
highlights and spots
picked out with a putty
eraser.

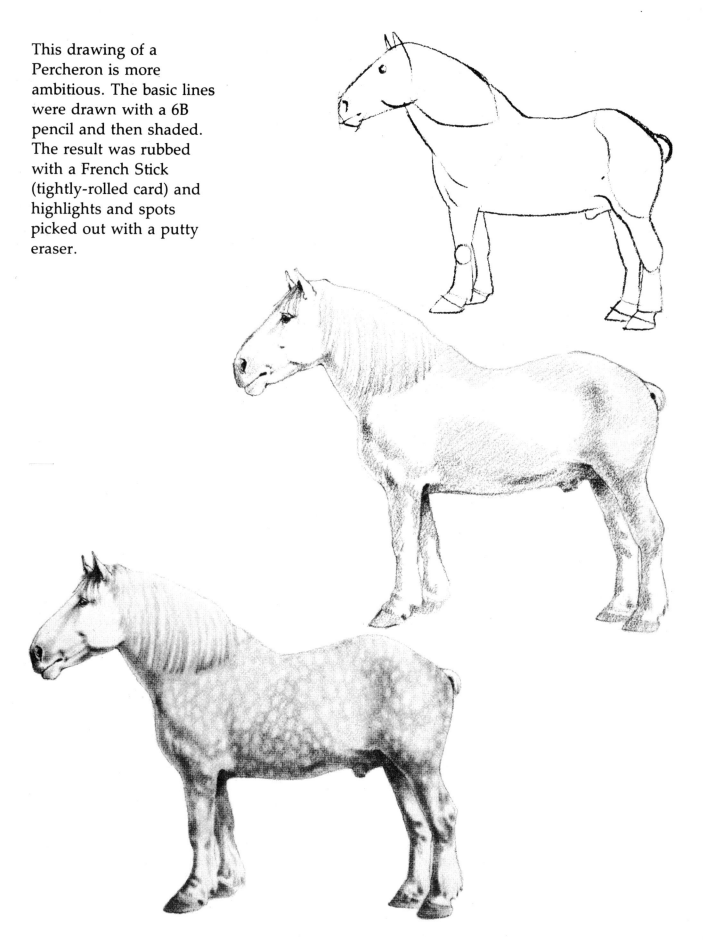

Here, I drew the pony's basic lines with a 2B pencil and, using the pencil's guidelines, added the details with a fibre-tipped pen. Finally, I lightly-brushed one edge of the line with clean water. This is not an easy technique to control.

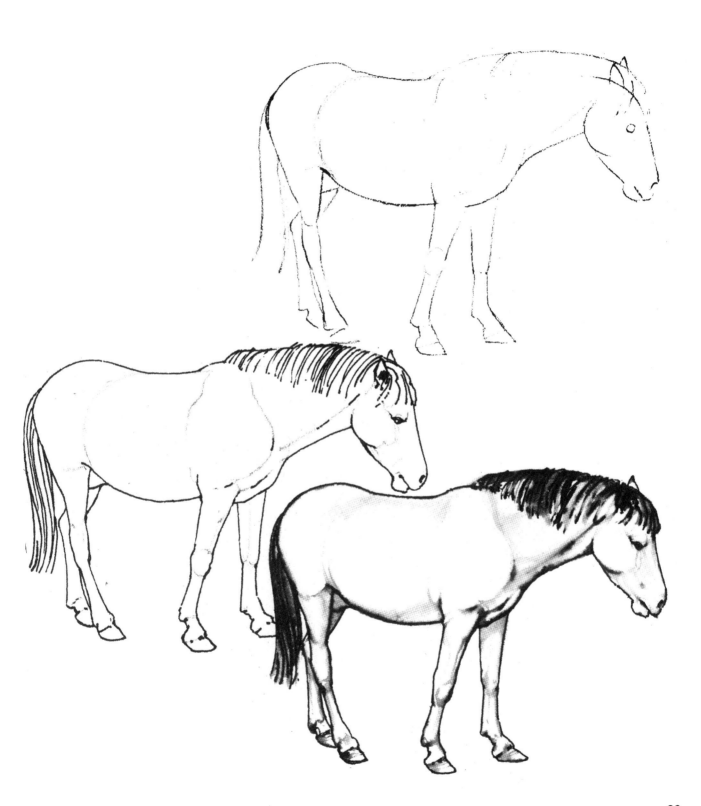

This Pinto's basic lines were drawn with a carbon pencil. The drawing was then developed in pen-and-ink and dabbed with a finger. Finally, a light wash was applied with a brush.

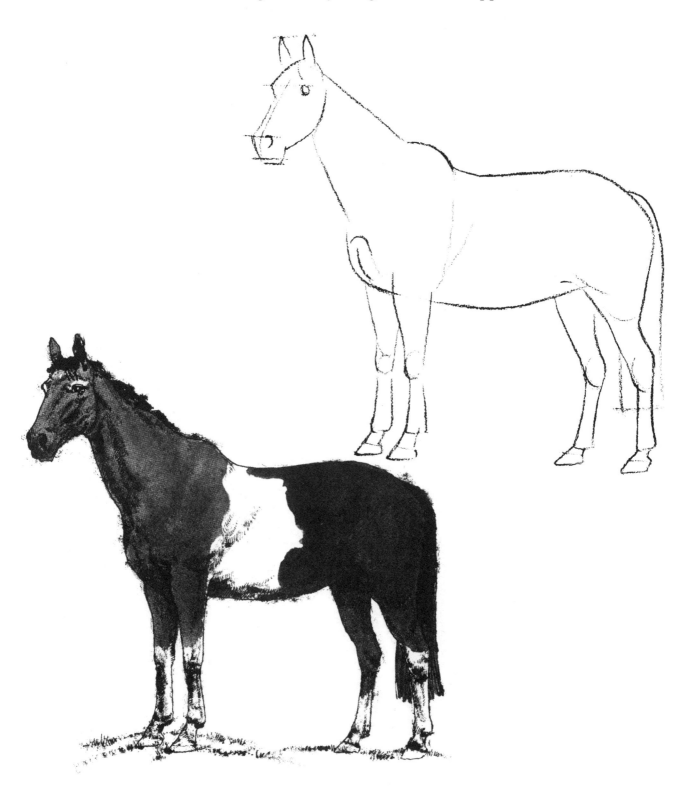

How not to draw from photographs

If possible, always draw from life. If you need to rely on photographs, choose only good-quality ones, and always try to represent the horse as living and three-dimensional. Here I have deliberately shown what *not* to do. The drawing on the right is flat; no thought has been given to the rounded shape of the subject. Also the pencil has been used as a paint brush; it would have been better to apply a wash of ink or paint. The drawing on the left is obviously made from a bad photograph; entirely white areas are seen alongside flat, harsh areas of shading which show no detail, even in the eyes.

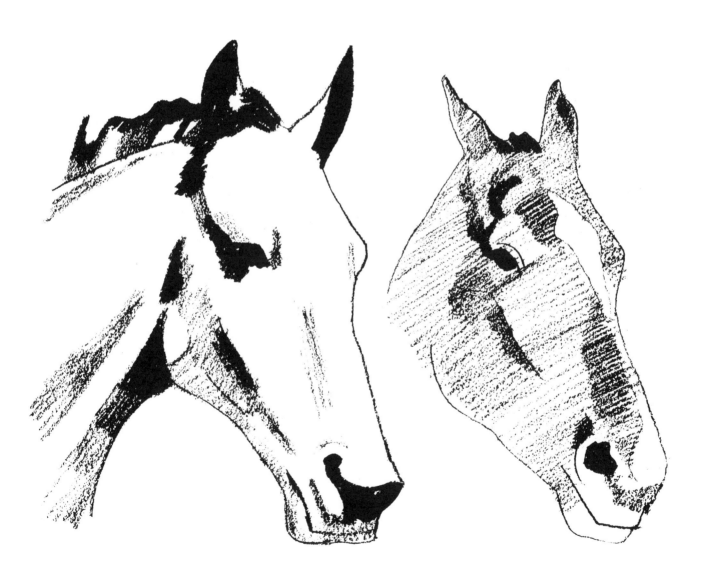

Unusual positions

Go for unusual positions; be adventurous. The drawings on these two pages are examples of somewhat unusual front and rear views.

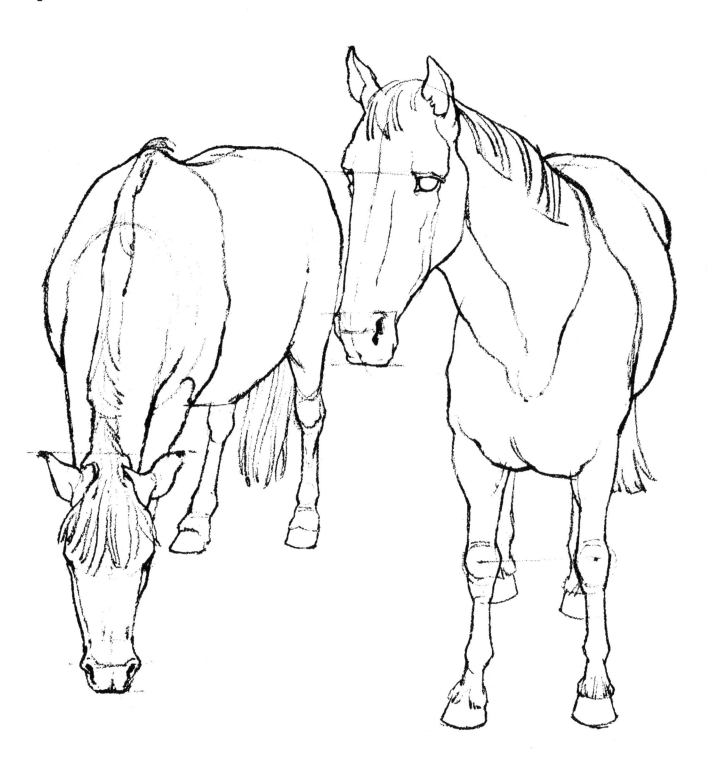

Like the drawings opposite, this one was made with a soft charcoal pencil. Notice that the unusual viewpoint brings out the rounded shape and shows how one part of the body fits into another.

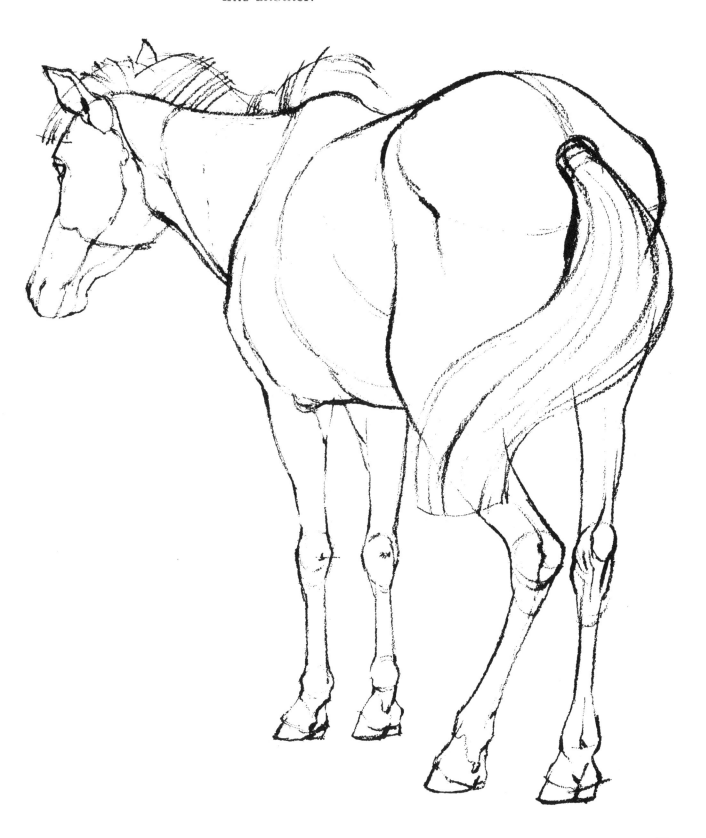

Drawing movement

Drawing a moving animal is not easy. If you are a beginner, you would be wise to start with a horse whose movements are minimal—one who is grazing or walking leisurely from one grazing spot to another, for example. Again, don't limit yourself to a single, obvious, viewpoint.

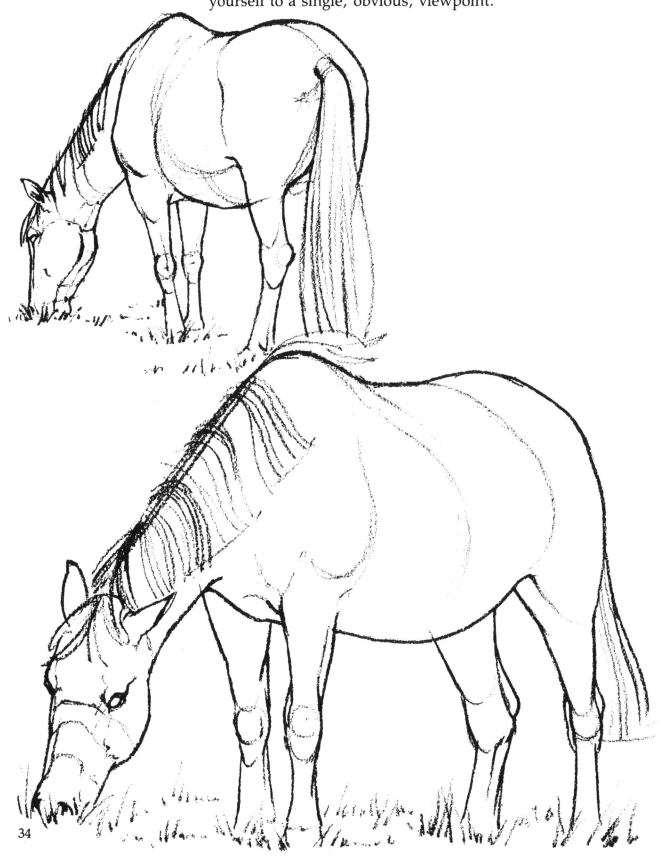

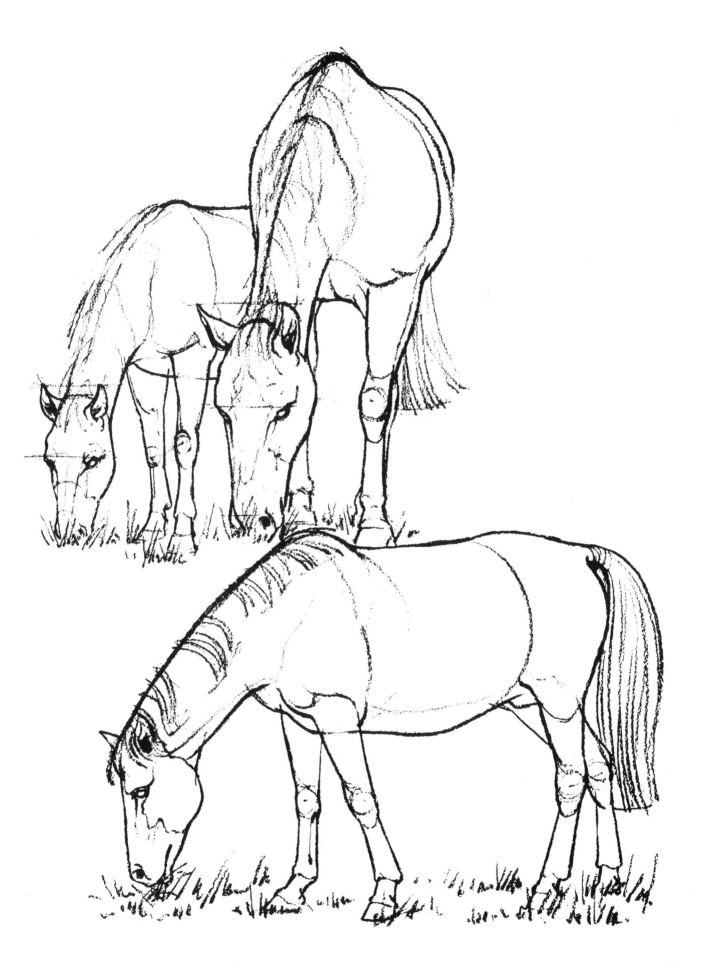

When the horse is moving, watch it closely for a while, before drawing, to study its shape and body movements. Then quickly draw as much as you can from memory, concentrating on the basic form rather than detail. Don't worry if your first results are not successful. Go on to make other quick sketches.

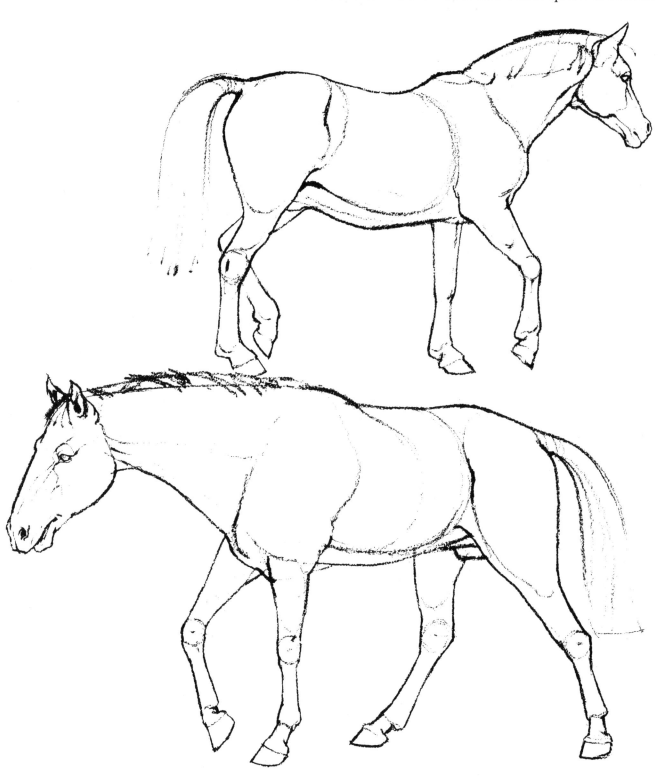

With practice your observation and memory will both improve until you are able to reproduce most of the lines of the body. You can add facial details when the horse is standing still.

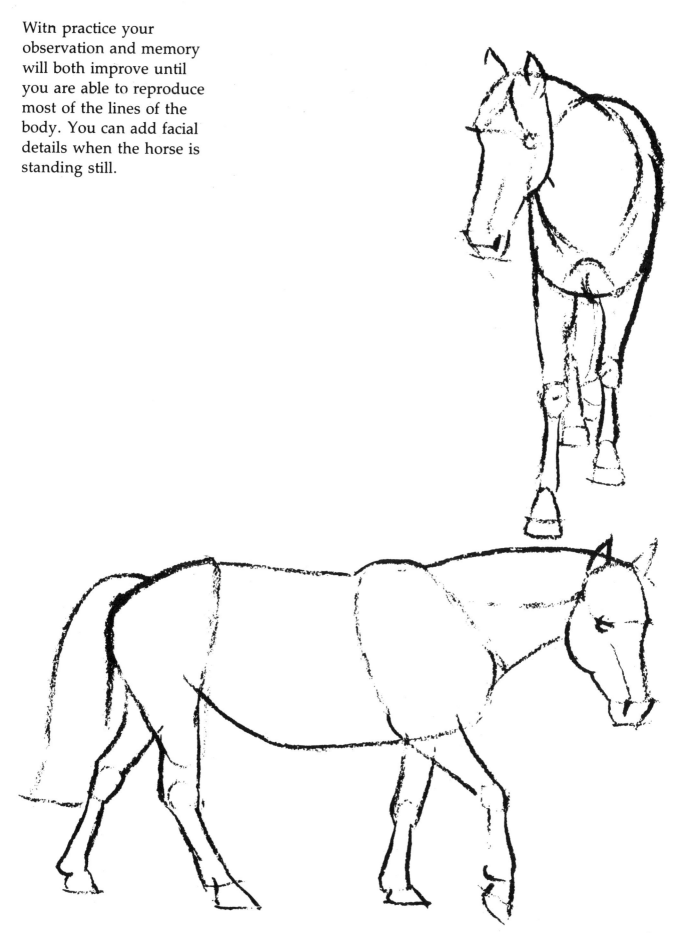

Horses running or jumping are difficult for a beginner to draw from life. It may be better to use photographs. But remember once again to use only good-quality ones; and draw quickly to encourage your observation and get movement into your lines.

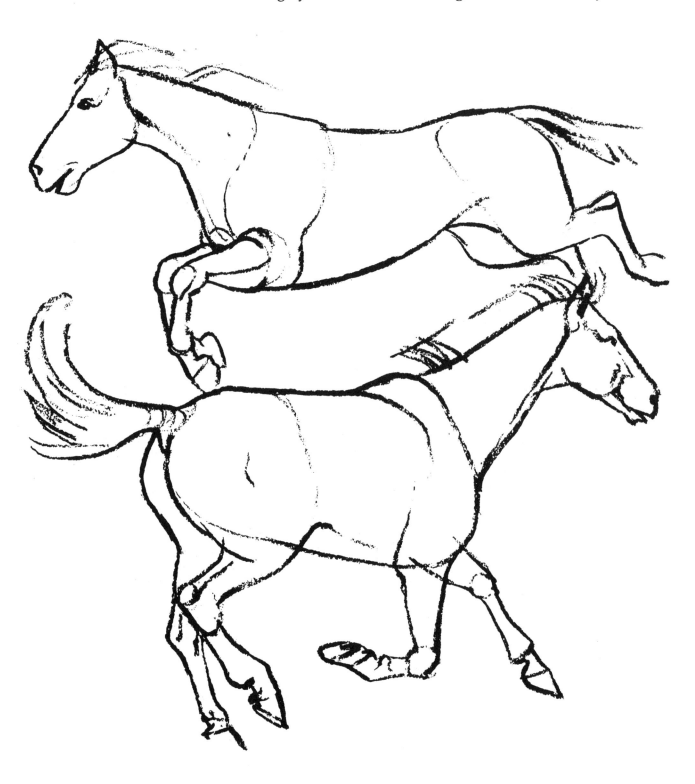

Here are two 'jumping' drawings made from the same photograph. A shows the anatomical form, B the basic lines.

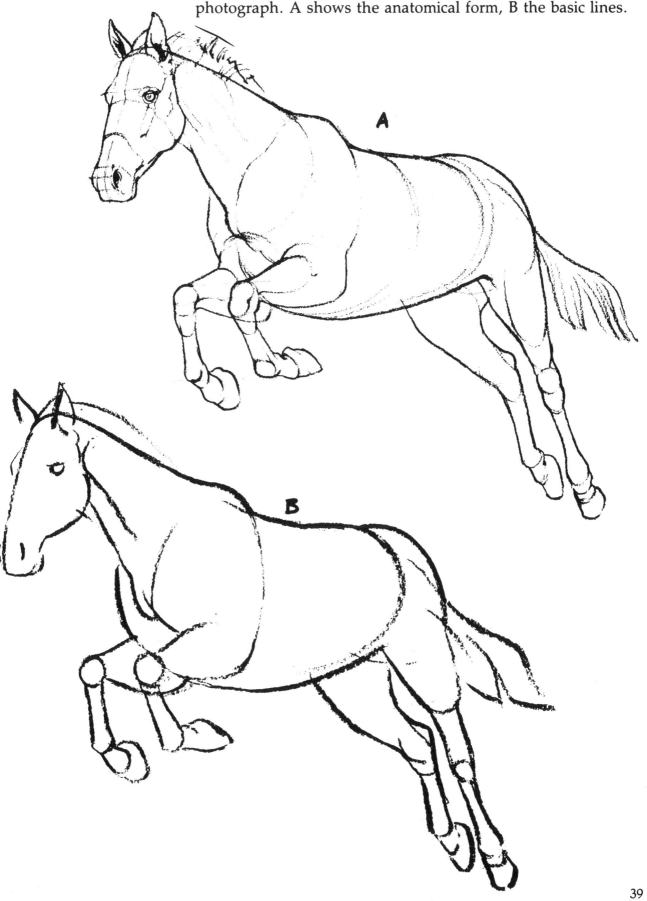

Different techniques

The Przewalski below was first lightly outlined in pencil. I then used masking fluid to paint all the areas I wanted to remain white—on each side of the pencil lines. When this was dry, I painted the whole area with Indian ink (the right-hand side of the drawing has been left at that stage). When the ink itself was dry, I used an eraser to remove the masking fluid.

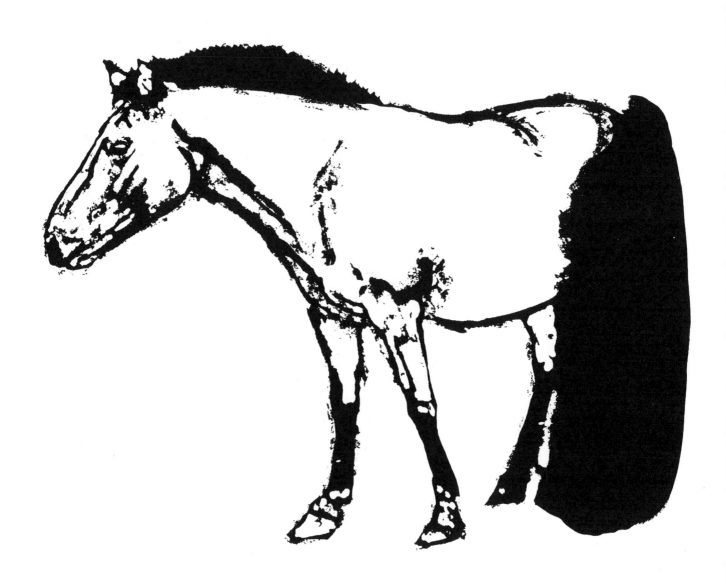

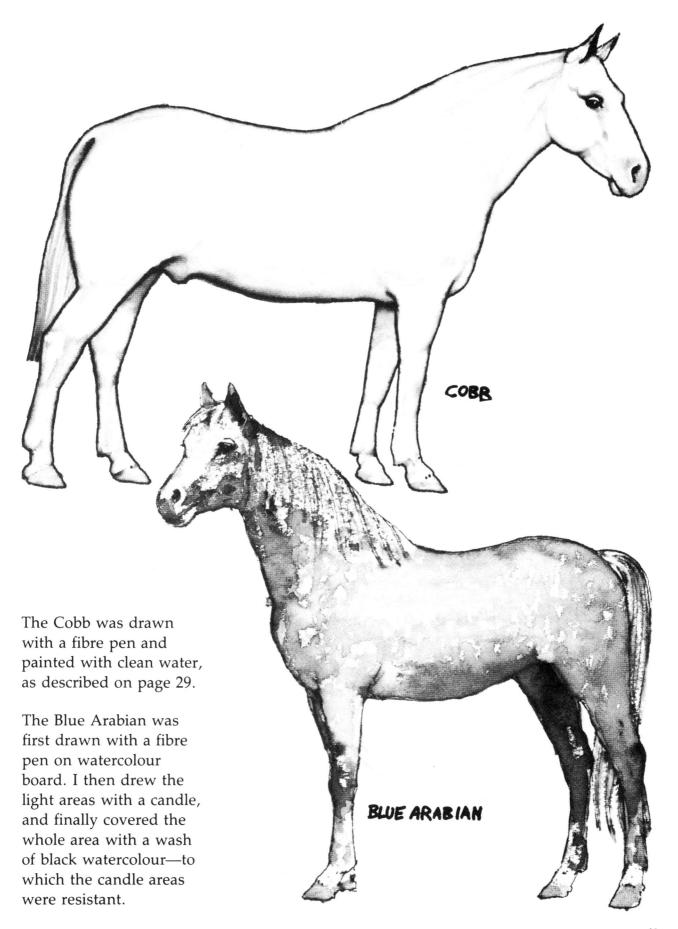

COBB

BLUE ARABIAN

The Cobb was drawn with a fibre pen and painted with clean water, as described on page 29.

The Blue Arabian was first drawn with a fibre pen on watercolour board. I then drew the light areas with a candle, and finally covered the whole area with a wash of black watercolour—to which the candle areas were resistant.

The Clydesdale here was drawn with a felt marker—which is ideal for portraying the strength of the horse, although not a good medium for detail.

The Morocco Pinto was drawn with a brush and black watercolour paint on watercolour board.

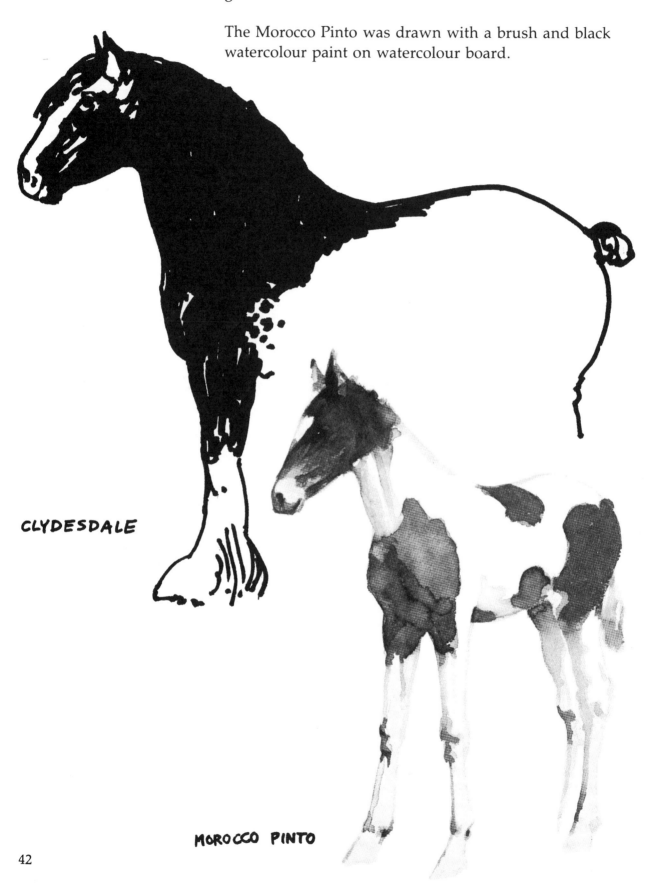

CLYDESDALE

MOROCCO PINTO

This is a Tennessee Walking Horse, drawn with a stick of medium-thick willow charcoal. I used the side of the stick for the broad strokes on the body.

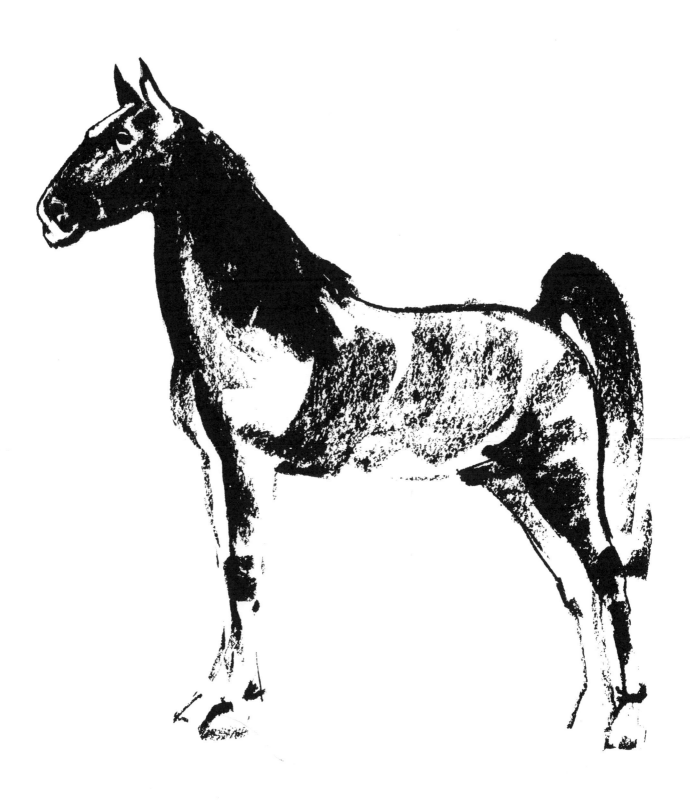

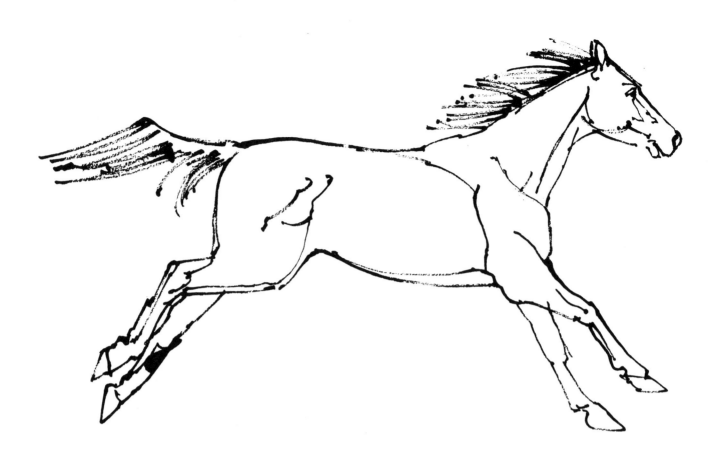

To capture the movement in these horses, I drew with the handle of a brush dipped in ink.

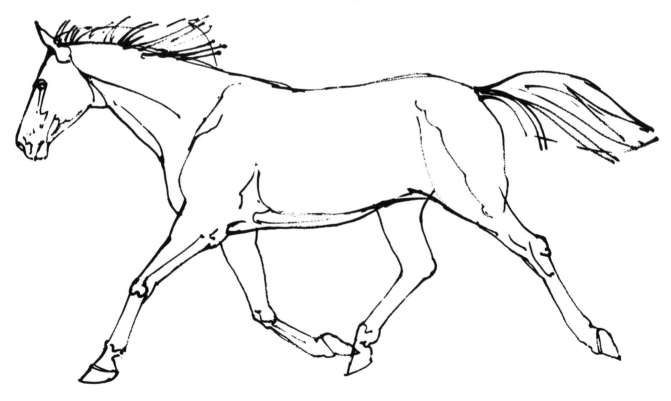

The Mongolian pony (top) and the Ardennais (bottom) were drawn with a wax crayon on a rough-surfaced cartridge paper.

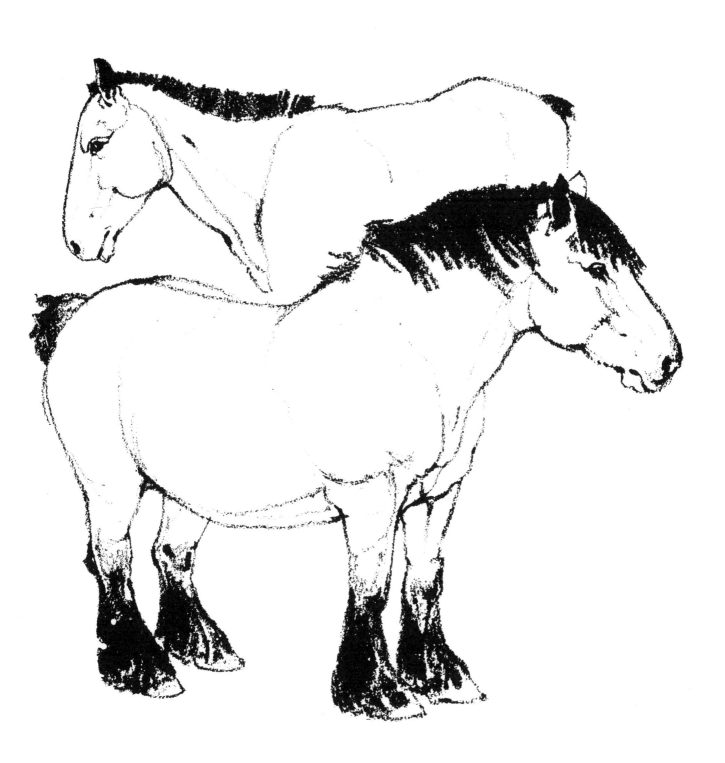

A fibre-tipped pen—used for this drawing—is a very useful medium for sketching.

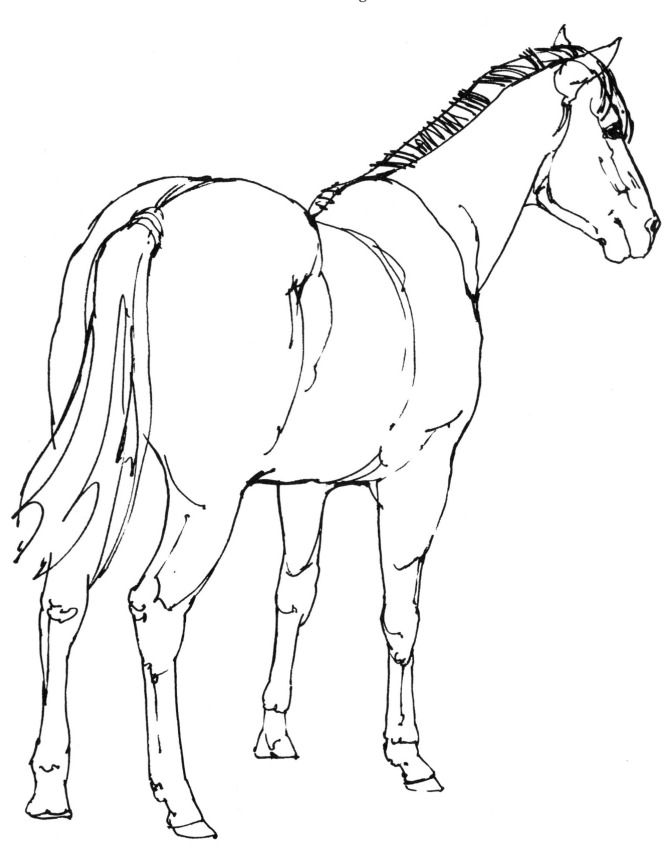

This is a pastel drawing on Ingres paper—of a Dutch Draught Horse. I used only black and white pastels: the middle tone is provided by the paper.

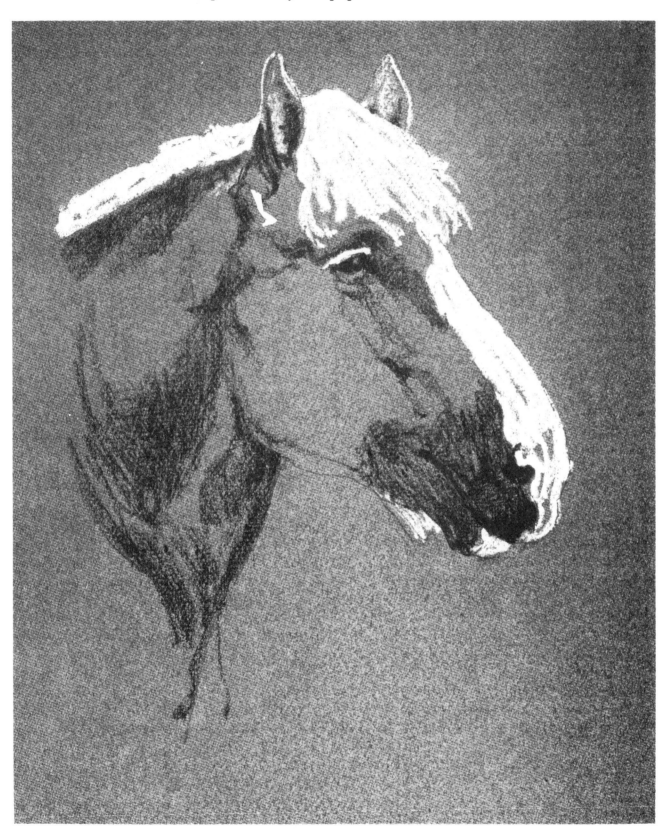

Pastel crayon on rough cartridge paper produced the bold treatment here of a pony. The edge of the stick made the fine lines and the side made the broad ones.

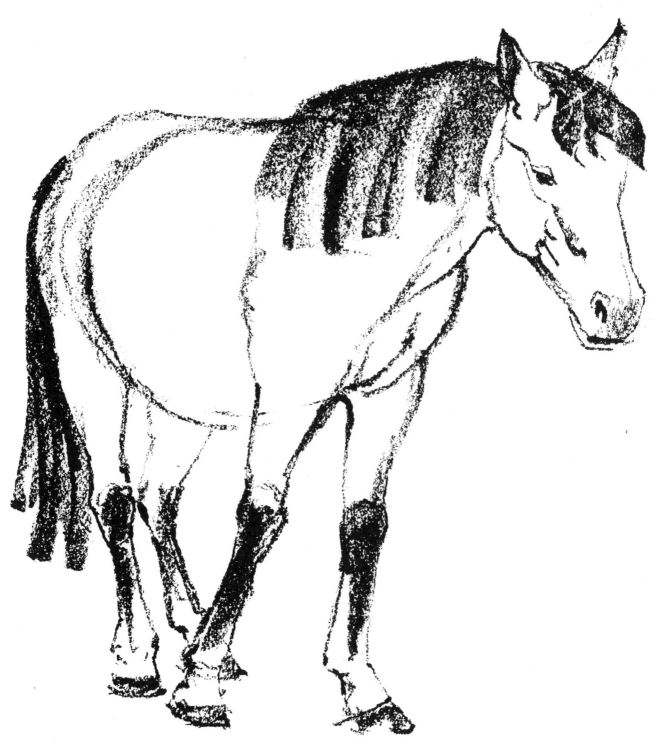